Eighteen Photographs

Eighteen Photographs

Foreword by Ben Maddow

Introduction by Charis Wilson

Peregrine Smith, Inc.
SALT LAKE CITY
1981

Copyright © 1981 by Cole Weston and Peregrine
Smith, Inc.

Library of Congress Cataloging in Publication Data
Weston, Cole.
 Cole Weston, eighteen photographs.
 1. Photography, Artistic. 2. Weston, Cole.
I. Title.
TR654.W445 779'.092'4 80-28230
ISBN 0-87905-084-5

First edition.

Manufactured in the United States of America.

Dedicated to my children: Ivor, Kim, Cara, Matthew, and Rhys (1955-1971).

I wish to thank all of my dear friends who have helped to make this book possible, and a special thanks to: Gibbs Smith, Ben Maddow, Charis Wilson, Dave Gardner, Michael Hoffman, Wendy Byrne, Randy Efros, Mike Parak, Ray Lyles, Myron, and Terry.

Foreword

How marvelous, how lucky for us was the invention of photography! Daguerreotypes, platinotypes, silver prints, autochromes—we've had nearly a century and a half of these pleasures. They are a new art, mysterious in their relative ease, and powerful in their close correspondence to reality; and sometimes accused, ignorantly I think, of corrupting our moral view. Nonsense: we don't need an art to corrupt us; that can be achieved without the assistance of the camera.

Not that a photograph is without consequence. By condensing the truth of things within the frame of the artist's vision, it widens our perception of what may be beautiful. Of course, a photographic print can be disturbing, and even morbid; but mostly, by the very intensity of its detail, it is joyful.

This joy is very particular in Cole Weston. To a native-born alien like myself, he is the essential American, and more than that, almost an American of the marvelous 19th century. He has four or five talents, or even more. His pursuit of happiness is relentless. Although not untouched by tragedy, he is optimistic, cheerful, cordial, hopeful, progressive. Alongside his obsession with photography, he has worked as an actor, and has directed regional theatre—not cynically but with frank enthusiasm. He is equally skilled and energetic in business, in which, often enough, he invested his own physical labor—another good 19th century American virtue. Twelve years ago he bought a 50-foot double-ended ketch, a sailing vessel already 45 years old, and learned navigation and sailed it himself, with five children and a wife aboard, down the Pacific coast, through the Canal, and into the archipelago of the Caribbean. In 1973, with a film crew and two grown sons aboard, he sailed west into Melville waters, Tahiti and the Marquesas. These were adventures most men only imagine; but with Cole Weston the thought is nothing until it is made tangible.

The exuberant, happy force of the man shows in all of the prints in this book. Half of them are views that might easily have been taken just after May 18, 1839, the day Morse brought the daguerreotype to America. They stand solidly within the tradition of American landscape painting; they are saturated with a glowing, romantic light, such as one finds in the paintings of Alfred Bierstadt or Thomas Cole, where the works of man are absent or distant. The land of Emerson and Thoreau was the source of inner quiet. Cole Weston's prints have this mystic, op-

timistic quality; they are both noble and closely observed. How grand the Pacific Ocean is in his famous print: mist, spray, wet stone, and the rush of salt water—no pollution here, as there was none when the first European ground his keel ashore on its majestic beach. What we see, through Cole Weston's lens, is not an illusion but an ideal. And it is seen through color; and color is not just another branch of photography.

In some important ways color photography is a brand new way of seeing—and illuminating—the real world. It is not only that in monochrome, light and shade are simply values of black and white, while in color, light will be yellow-green and an adjacent shade, blue-green. There is also another, less conscious dimension, with its own peculiar laws. To each hue, and to each grade of saturation of that hue, and to the field of color in which it glows, there corresponds a mood inexpressible in words: a weather, a landscape on the great inner continent of the mind. To feel these powerful subtleties takes not so much training as instinct.

Color has a complication of values, all the more because the world as we see it, and indeed the universe, is colored by its infinite frequencies. Thus color prints are more dense with real associations than black-and-white, and also more vulnerable to the ways in which we may distort the purity of vision.

Cole Weston has this sense of color perception, perhaps, from his father. Of course one carries forever the burdens of one's forebears; the four Weston sons are no exception. But there are gifts, also: a Weston inheritance of color as emotion. Edward Weston wrote, after visiting friends in 1924, "One carpet of an intense green and red vibrated so violently as to actually dizzy me. I could hardly look at it." And about his room in Mexico City: "I am to have one of my dreams fulfilled —a whitewashed room; the furniture shall be black, the doors have been left as they were, a greenish blue, and then in a blue Puebla vase I'll keep red geraniums!" And of the Mexican night—which we often, wrongly, assume to be shades of white, silver, and black, "Tonight a full moon, brilliant, almost dazzling—around it a delicate green light and, still further encircling, a halo of orange." At the end of his life, Edward made a couple of dozen 5 x 7 color transparencies; they are intense and beautiful. Cole was Edward's partner during his father's last days as a photographer; so color was a natural part of his insight from the very start of his career. And that interest has continued, always deepening, for the past thirty years.

All of his prints are seen and made with a refined sensibility. Cole Weston doesn't fancy the softly-tinted, softly-focused roses or posed figures that some consider delicately old fashioned; nor is there anything in the body of his work like

the dismembered and ill-natured color that many a young photographer pulls out of a color Xerox. He does not care for bright color prints of dull places dully composed, a fatigued aesthetic that owes a lot to the dead cult of boredom, nor are his prints morbid. Instead, his work is consistently honest, straight, strong, and vigorous even when sad.

In the delicate illuminated glow of the meadow grasses, in the cream-white intensity of the young aspens; in the broader strokes of the silver river etched into the land; in the white-hot needles of the cactus; in the wind-torn wood drifting quietly among lily-pads; in the tawny, naked rock of the canyon; in all these prints we see an America, a real paradise, endless in all directions, under the unbroken arch of the sky, that was described by the earliest pioneers. Except for the skin tents of the hunting tribes, and the sparse houses and ovens of the Southwest agricultural tribes, man had made little mark on this superb landscape. There were no iron axes on this continent for all the geologic ages till the present.

The Europeans came in their troubled millions, put up fences, pens, and barns, scarred whole valleys with their mines, erected chimneys and cities, cut up the American world into railroad sections. A generation of painters, particularly in the East, and more particularly in the manufacturing towns of New England, began to celebrate the works of man on the landscape: factories, towns, wharves, churches, and locomotives.

Cole Weston, by temperament and education an outdoor American, did not, as Stieglitz did, celebrate industry. But in his broken and abandoned sheds, in his moist and rotting wharves, in his study of vigorous ferns against old walls, in his appreciation of the weathered plank and the torn screen, he has photographed the passage of rural time. Man's rude work becomes subtly beautiful in his eye, colored at last by the grays and umbers of decay. On the other hand, as he himself grew older perhaps, he saw that certain human patterns, the zigzag of fences, a distant trail of smoke, the white gable of a comfortable house seen beyond tawny grass and through a set of obtuse angles formed by trees and their shadows—he saw that these familiar human views had their own kind of loveliness.

We know that color in itself has certain formal qualities: some tones recede into the distance, others advance, shouting; and it is not only ultramarine or scarlet that have these spatial qualities. Cole Weston has begun to work with such complex tonalities. The very close eroded surface of an iron boiler has the rich pattern that is the common heritage of American abstract painting since its beginning in New York in the 1940s; but he is aware that nature is infinitely more complicated

than anything one can put down with a brush.

So it was perhaps not merely some technical difficulty that delayed the flowering of color from its invention in the 1860s, but an aesthetic problem as well. Technique of printing color has now become a lot easier—easier, as some photographers say, than black-and-white. It is now a good time to explore the world all over again, just as it is—a chromatic mixture of the natural and the constructed—and respond to the force of the ugly and the solace of abstraction, each to be newly grounded in the complexity of color. It is time for the photographer to bring back a personal monograph of this journey, as one of its real pioneers, Cole Weston, with his exceptionally clear and tender vision, has done here for us to contemplate.

Ben Maddow
December 1980

Introduction

Had you been strolling along the waterfront in Monterey, California, on a midsummer morning in 1947, you might have observed two men—the younger carrying an 8x10 view camera attached to a sturdy tripod, his shorter and frailer companion walking with difficulty—as they made their way out onto the rickety pier that used to stand just west of the old wharf. You might have watched as the older man, with considerable help from his companion, made an exposure of the gaudy pink, blue, and yellow sheds that perched above the dark pilings of the old wharf, and the solitary white skiff that floated before them. If so, you would have been witnessing an event that would lead, in time, to the photographs in this book.

The younger man was Cole Weston, then twenty-eight, and he was assisting his father, Edward Weston. Eastman Kodak was sending generous supplies of color film to Edward, hoping to convert him from his life-long devotion to black-and-white photography, but he was by then too disabled with Parkinson's disease to take much advantage of the material. There was always film left over—expensive, perishable, 8x10 color film—and Cole began "using it up so it wouldn't go to waste." From the start he found it visually stimulating. He was also keenly aware that it offered him a photographic field of his own where neither his father nor his brother Brett had staked any serious claims. So you could say that's where it all began.

Beginnings are tricky things, though, and nothing ever starts where it seems to. How did it happen that Cole was ready for color film when it was suddenly available? He hadn't started out, as Brett had, to follow in his father's footsteps; in fact, he'd done his best to avoid that path. It's true he acquired his first camera when he was sixteen (he says by trading Brett a pair of pants for it; Brett stoutly maintains that he stole it) but it wasn't used for anything more than casual picture-taking. Cole's first career choice was acting.

Being the son of a famous father has never made growing up easy, and being the youngest of four such sons compounds the difficulties. We tend to think of native Californians, growing up in the free, fenceless suburbs of the early 1900s, as children of good fortune; but the memories of Cole's childhood that surface most readily are of fearful and painful experiences: a neighbor poking him with a cane through the bars of his crib, a fall from a tree that broke both his wrists, a

11

dangerous bout of diphtheria. He was four years old when he watched his father and oldest brother sail away to Mexico; two years later—after a brief reunion with his dad—he watched the same scene repeated with his next-to-oldest brother. Reunions were all too brief, and, even when Edward was "at home," he didn't live in the house with his wife Flora and the boys but stayed in his studio two or three miles away. Although a child may take a parent's continuing presence for granted, repeated or prolonged absence is soon read as desertion and abandonment; no wonder Cole's view of those years is that his father "was never there." This might have been less harrowing had his mother been of a mild and nurturing disposition, but Flora was a feisty scrapper whose own wounds were concealed by a stoic pretense that all was well. Left with a two-parent job to carry on, she favored the "father role" of command and admonishment.

Under such stress a child may give up and turn passive, or may develop a strongly competitive nature. Younger children, who cannot yet risk direct competition with older ones, are likely to cloak aggressive tendencies in perpetual teasing, as Cole did throughout his early years. He steered clear of the territories his brothers had staked out for themselves—left-wing politics was Chandler's domain, photography was Brett's, boats and the sea belonged to Neil—and looked around for something of his own. At one time Edward was convinced that his youngest son, who came home from high school most afternoons and danced with his girl friend to the living-room phonograph, would grow up a happy extrovert and become a successful businessman, thus avoiding the perpetual struggle for money that occupied the rest of the family.

This belief was shaken when Cole, on the strength of a minor part in his high school senior play, decided on an acting career. Although Edward knew that actors were as liable as photographers to lead indigent lives, he negotiated a work-study scholarship for Cole and shipped him off to the Cornish School of Theater in Seattle to learn the trade. For the next three years Cole built scenery, worked lights, danced, acted, and directed, earning his way as janitor, fencing instructor, and stage manager.

A graduate in Theater Arts, and newly married to fellow student Dorothy Hermann, he returned to Southern California in 1940. Finding no ready market for his new skills, he went to work for Lockheed Aircraft at fifty-one cents an hour, and joined a little theater group to keep in practice. The bombs that fell on Pearl Harbor changed the course of many planned careers; when Cole joined the navy in 1943 he was whisked through a Great Lakes boot camp, set down in Norman,

Oklahoma, and instructed to serve as public relations photographer for the base. Thus the navy opened a back door into photography that Cole could enter without misgivings about competing with his father and older brother.

Cole maintains that he didn't take much note of photography before his high school years—he just knew it was the way his father earned a rather precarious living. However, like his brothers, he had always been exposed to every aspect of the medium: he could probably identify the smell of hypo earlier than he could the smell of licorice, and recognize a lens cap before he knew what a baseball cap was. A darkroom was as necessary to a house as a kitchen or bathroom; the lines put up, on first moving to a new place, had nothing to do with laundry—they were taut wires on which negatives and prints would hang to dry. The guillotine blade of the big paper cutter, the massive bulk of the dry-mounting press, the turning faces of new prints circling in the wash water, the mounted prints stacked in cupboards, packaged for mailing, or set one by one on an easel to show visitors, even the scraps trimmed from mounting stock that shopping lists were written on—all were familiar elements in the special environment that shaped his consciousness.

Anything Cole had missed in the way of photographic basics he now picked up in daily practice. He immediately wrote to Edward for his "formulas," having no doubt—he says—that they would serve to bring his prints up to Weston quality. With a well-equipped darkroom and an 8x10 camera for his own use, he took to roaming the countryside in his off hours, photographing old buildings and river-bed debris. He was also doing a brisk portrait business making pictures for the men to send to their wives and girl friends, until the navy decided he was over-charging at thirty-five cents a portrait and put a stop to the enterprise.

With the end of the war, Cole had returned to Southern California and worked on a few assignments for *Life* magazine when a letter from Edward broke the sad news that he had Parkinson's disease. He needed an assistant who could take over the darkroom work and help him in other ways. All he could offer in exchange was room and board and some photographic training. Cole and Dorothy packed up and moved to Wildcat Hill in Carmel Highlands, even though it meant cramming themselves into the diminutive workroom called "Bodie-House."

Most of the apprentices who had worked with Edward through the years had become accomplished photographers, and Edward's efforts had been directed toward helping them to strengthen and clarify their own vision. What he wanted Cole to master was the more difficult and exacting task of reproducing *his* vision. That called for exasperating hours and days in the darkroom redoing prints that

needed "a little more burning-in of this highlight," or "a little more dodging to hold back that shadow." To print Edward's negatives as he would have printed them was—in the last analysis—impossible, because when Edward was doing his own printing he changed his mind from time to time about which result most nearly reproduced his original vision. What Cole learned through his years of working at the job was how to come as close as possible to duplicating what Edward had already done, and at this he became as expert as changing photographic materials would permit.

In addition to this graduate course in printing, Cole helped his father on field trips as long as it was still possible for Edward to make them. Parkinson's disease made it increasingly difficult for Edward to work with his camera: by the time the photograph of the Monterey wharf was made he could no longer lift his foot over the tripod leg or get his head out from under the focusing cloth without help. At first Cole only had to place his father's hands on the focusing knobs; soon he had to hold them on; finally he had to turn the knobs for him. Cole's main recollection of that day on the pier is of his acute anxiety that Edward might stumble and fall.

After a brief appearance in the political arena, running as the Progressive Party's candidate for Congress in 1948, Cole bought some land a few miles south of Carmel in Garrapata Canyon and started a trout farm. By then he and Dorothy had separated, and in 1951 he married Helen Prosser. They had four children in the next eight years and Cole supplemented his income from the trout farm by directing plays for Carmel's outdoor Forest Theater. Cole also continued to assist his father until Edward's death in 1958, but during these busy years he managed to produce some notable work of his own.

Having schooled himself while making prints to see with Edward's eyes, he had now to make a constant effort *not* to see that way. He was helped by the fact that he was working in color, whose requirements obliged him to stop registering the black-and-white values of a subject and to develop a new set of perceptions. He was also obliged to deal with a new set of technical photographic problems because color was a far more complicated process. Most of his work in the 1950s, like the Garrapata Beach seascape, carried the additional hazard of making a critical exposure over the protests of a carload of kids yelling, "Come ON, Dad! Let's go HOME!"

A viral disease put an end to the trout and, in 1966, Cole was hired by the city of Carmel as the first director of its newly organized Sunset Center. For the

next three years he stage-managed such cultural events as the Bach Festival, directed occasional plays, and collected rents. In addition to an imposing office, he was supplied with a darkroom where he continued to print his father's negatives—a job left to him by legacy. He had married Margaret (Maggi) Woodward in 1963, and they had one son. Although these were Cole's most prosperous years to date, he became increasingly uneasy about the direction of his life and that of his family. Like many a man of 50, he put the crucial question to himself: Is this what I want out of life? A nine-to-five job with good pay and plenty of security?

The *Scaldis,* a newly-acquired 50-foot ketch, inspired Cole to make a clean break. He told the Cultural Commission he wanted a year's leave of absence. When the answer was no, he quit his job, rented his house, sold his car, loaded his wife and five children on board the *Scaldis,* and set sail for Europe. Maggi had never been on a boat, and she became ill before they cleared the bay. She stuck it out as far as Acapulco, then took the two youngest children and made her way home. Cole continued sailing with the older children past Central America, through the Canal, and on to Bermuda. Even though the trip didn't go exactly as planned, Cole says: "When I quit the Sunset job and sailed away, it was the best thing I ever did. Otherwise I would have been stuck there forever."

That first long expedition in the *Scaldis* echoed an earlier Weston voyage: almost 50 years before, Cole's father had burned his bridges and sailed off to Mexico in search of a new life. Cole left no tearful children on the dock when he embarked, since they were all on board with him, but otherwise the journeys had much in common. Such argonauts seldom reach the promised land they seek, but the severance from old life patterns and the embracing of new ones makes for a revised view of the world. One does not return unchanged.

The 1970s brought Cole the opportunity to conduct a series of photographic workshops in this country and abroad. Through them he discovered and developed a natural talent for teaching and, in turn, received stimulation that sharpened his critical perceptions and expanded the range of his vision. His sons have recently built him a darkroom-studio next to his house in Garrapata Canyon: a simple structure—like the house itself—it is specially designed to accommodate a dozen people at a time for workshop demonstrations.

Today Cole's technical skill in handling the tricky medium of color (where so much can go wrong so easily) serves a maturing vision and a unique viewpoint. He takes equal delight in strong visual designs and in subtle atmospheric effects. Sometimes design dominates, as in the Arizona water tank where he isolates an

area that resembles a world map colored by high-spirited children. Sometimes atmosphere takes precedence, as in the New Zealand landscape where a lacy veil of smoke, spreading across pastures and hedgerows, renders the smell and feel of the air almost tangible, or in the wave breaking on Point Lobos rocks where the color and force of a winter storm bind every part of the picture in a tension of surging water and flying spray. However, in most of these pictures, design and atmosphere are so closely interlocked that each must be seen in terms of the other, as when we peer up into the throat of the camouflaged cargo-parachute and detect the wind in the very act of reshaping its design.

Part of the pleasure in viewing photographs like these comes from that magical transformation by which a familiar scene is newly revealed. "The Palo Corona Ranch," says Cole, "is something I drove by for twenty-five years without seeing anything there, but on that day I nearly drove in the ditch in my hurry to stop and set up my camera." The result is this book's cover picture where the silver S of the road goes snaking over the cloud-shadowed hills, and the angus herd is scattered across the pasture like notes of a musical score.

The images in this first book of Cole's work are remarkable for the variety of light and color they encompass, ranging from the monochrome coolness of Haines Summit to the incandescent color of the cliffs in Cow Canyon, and often combining extremes as in the luminous herd of jersey cows against the somber New Zealand poplars. There are images that celebrate life and its cyclical patterns of growth and renewal. When Cole finds an abandoned Oregon cabin, we can see that he admires the crazy angle of the building, its mildewed shingles, and its green-framed window, but most of his attention is focused on the wild grasses, ferns, and blackberry vines that are as meticulously delineated as illustrations in a botany text. Again, in the lovely image of a Minnesota lake, with lily pads spotting the dark water and logs congregated at the shallow outlet, there are miniature gardens of mosses, grasses, and even small trees sprouting from the weathered logs afloat in the pond.

Such patterns of renewal may carry deeper meaning for Cole when he looks back on the thirty-year journey that has led from his father's white skiff by the Monterey wharf to his own white skiff at a Nova Scotia dock, and when he looks ahead to whatever stage is to come next in his own work or in the still-changing color process. No matter what the challenge, Cole will be eager to meet it.

Charis Wilson
Aptos, December 1980

Cole Weston

Eighteen Photographs

Farm, New Zealand, 1976

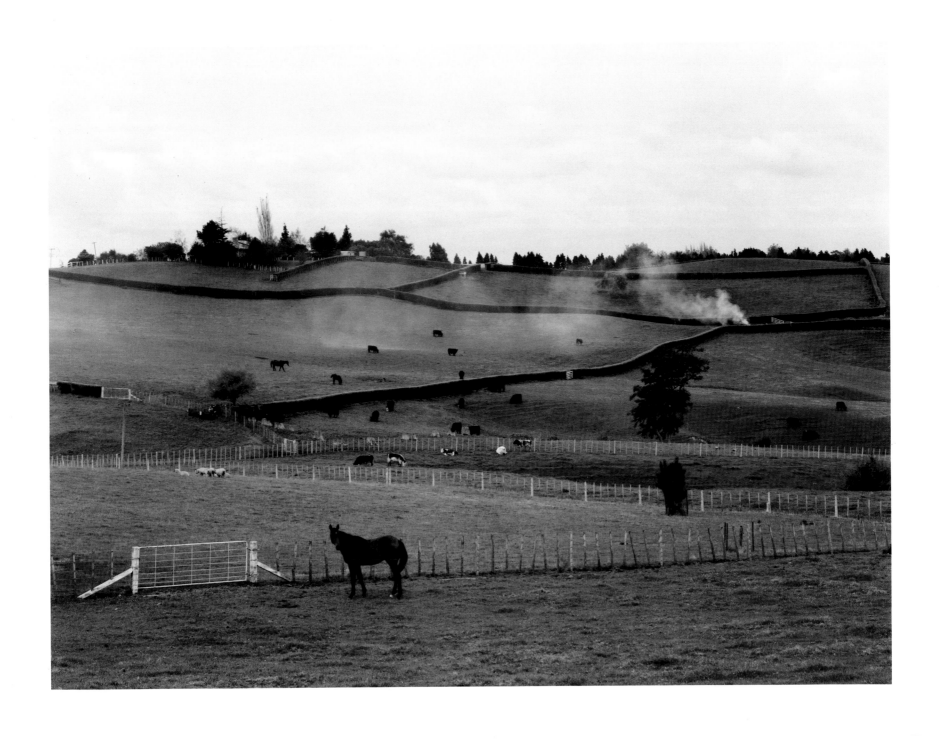

Surf and Headlands, California, 1958

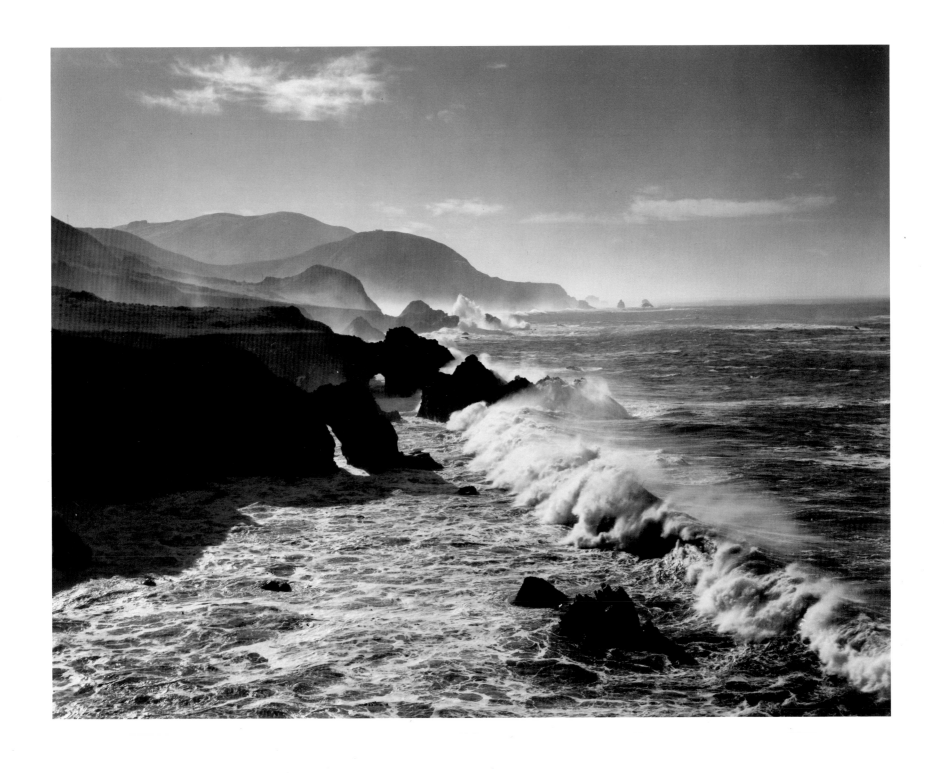

Knox Farm, Buffalo, New York, 1979

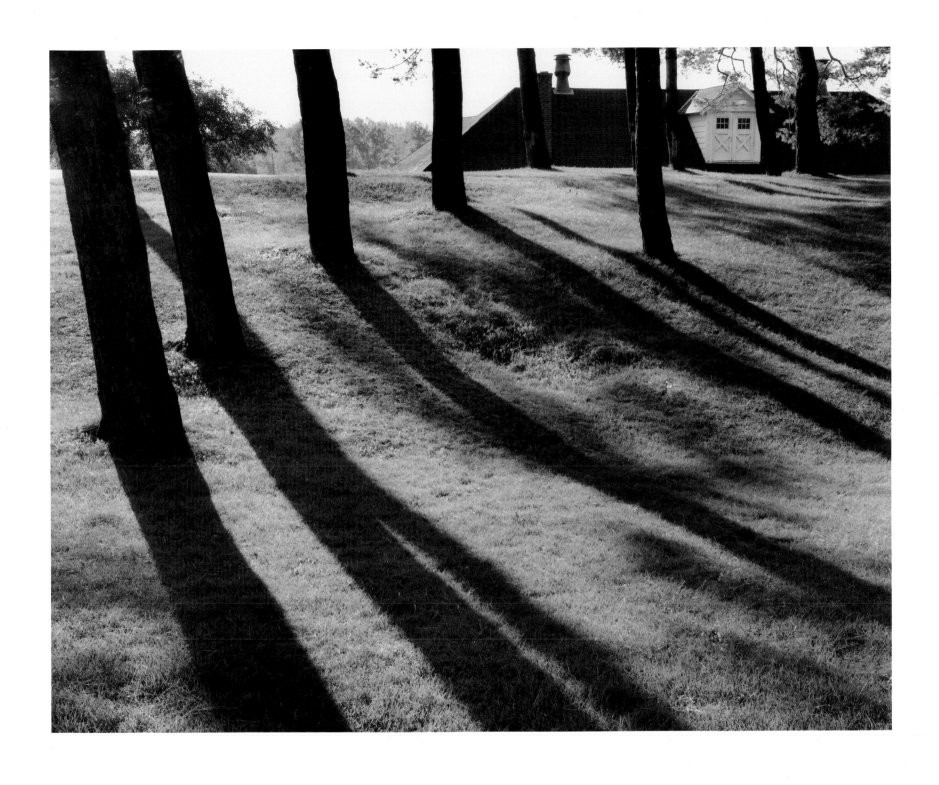

23

Deserted House, Oregon, 1975

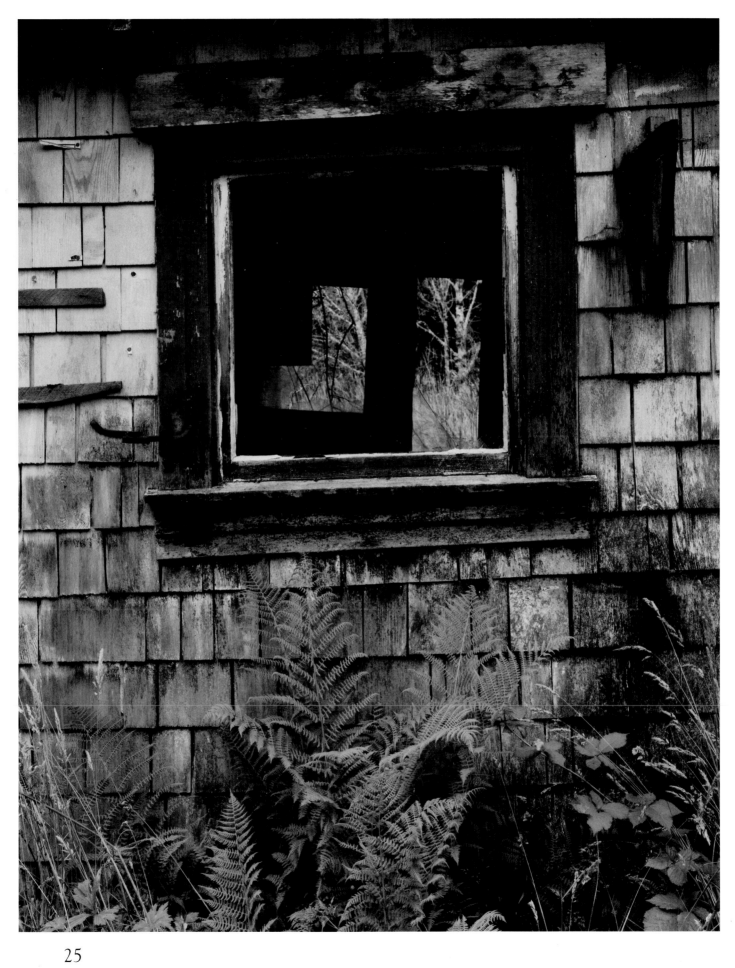

Hunt's Cove, Nova Scotia, 1978

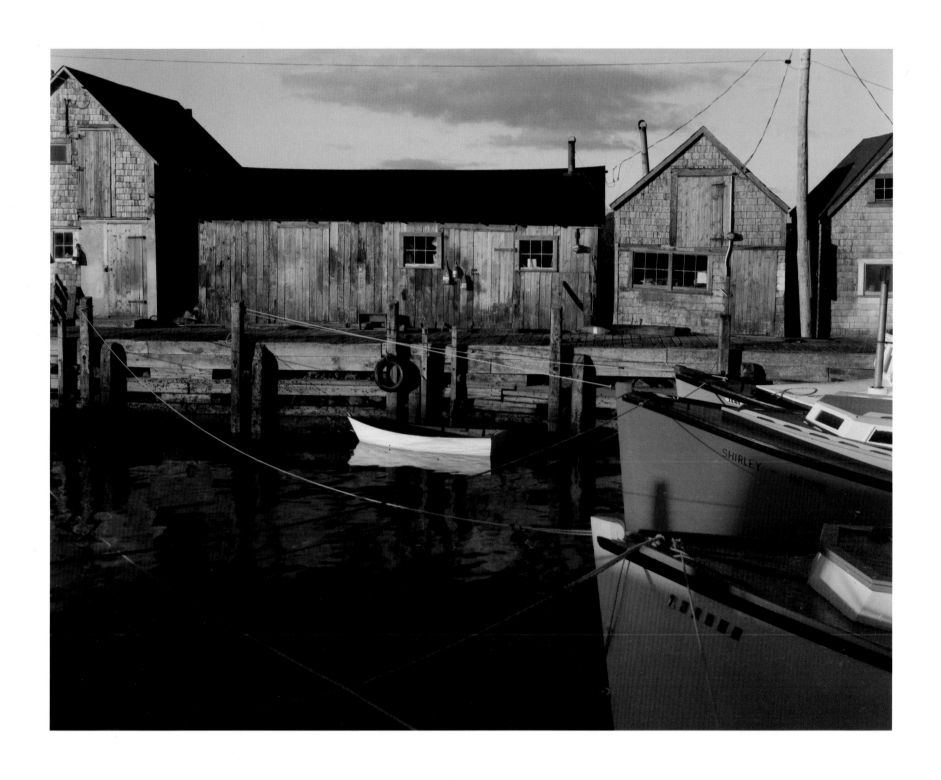

Aspens, Utah, 1978

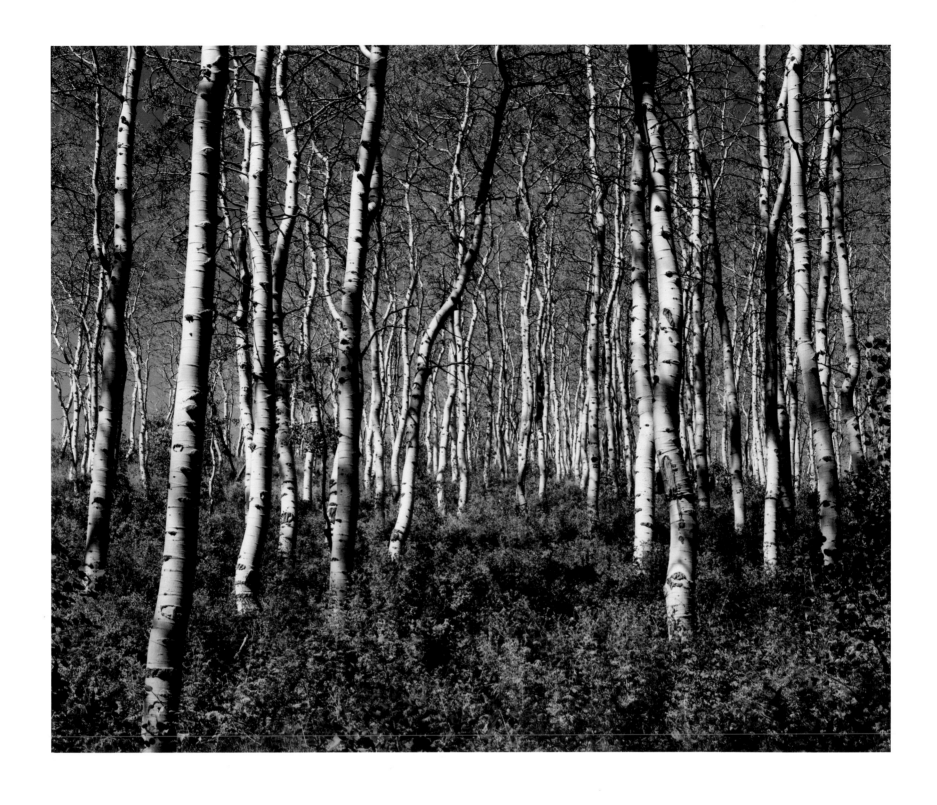

29

Yukon River, Alaska, 1975

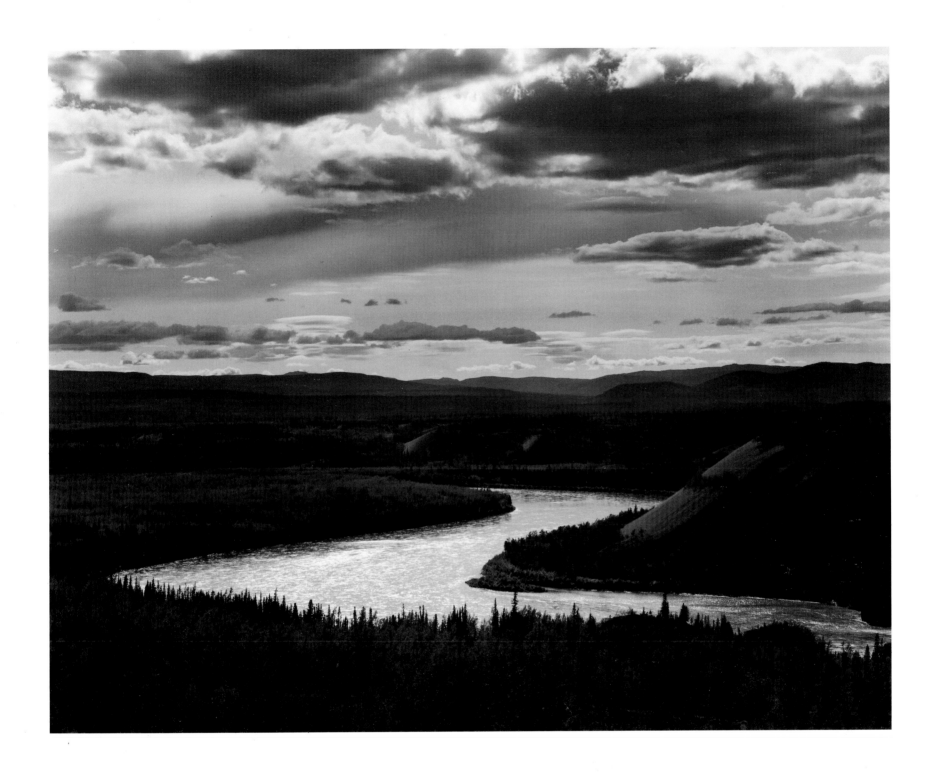

Nude, Arizona, 1979

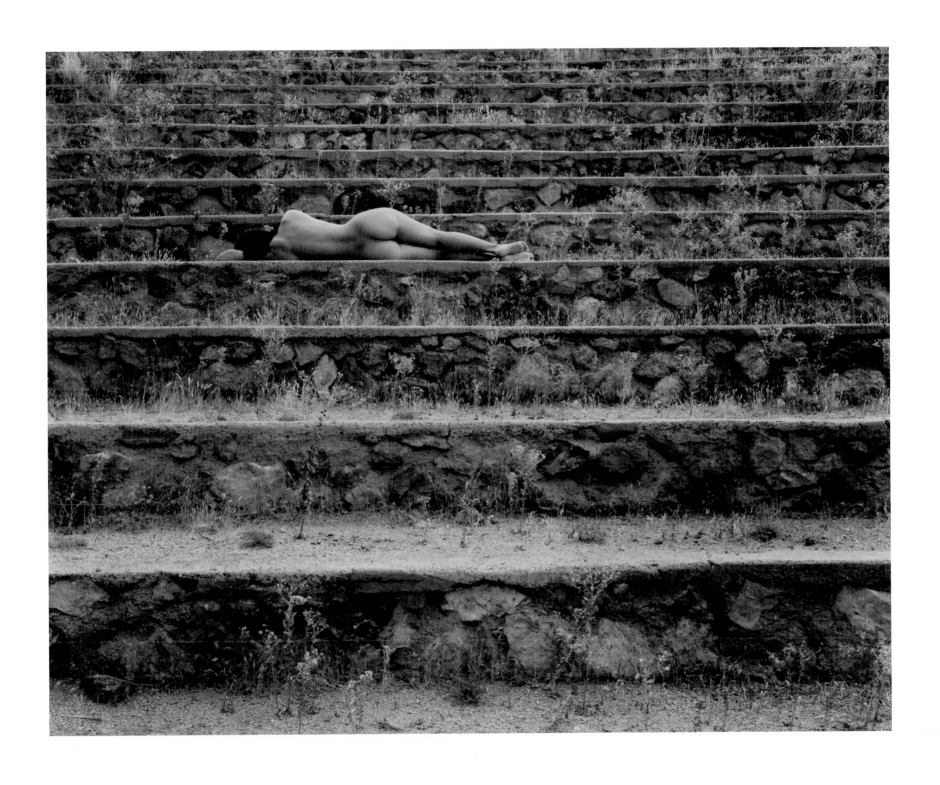

33

Parachute, 1979

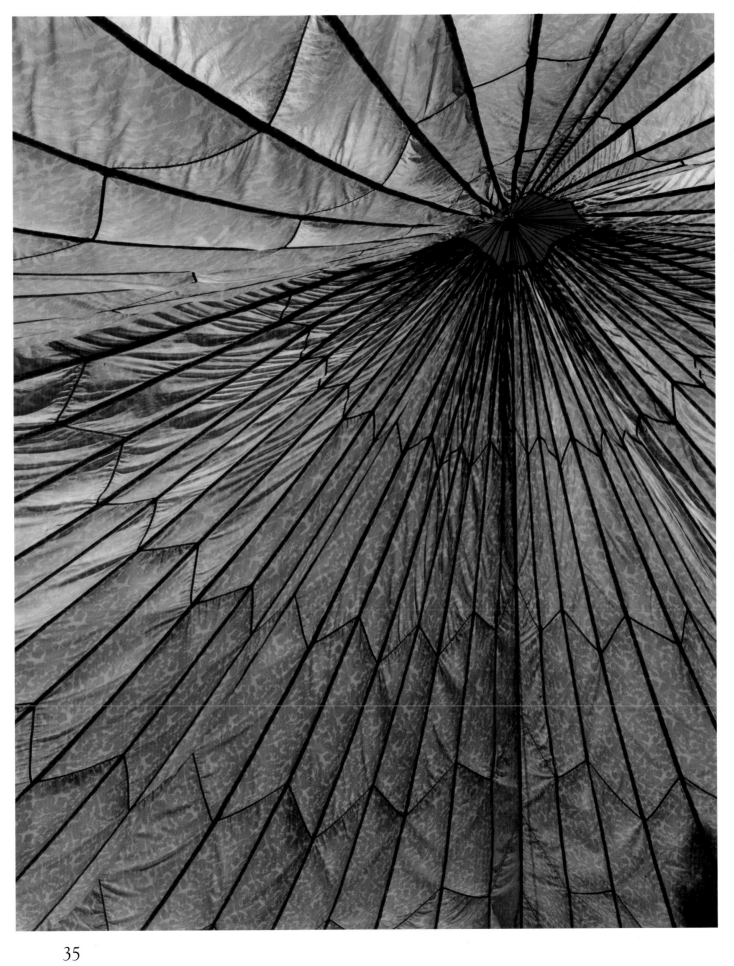

Jersey Herd, New Zealand, 1976

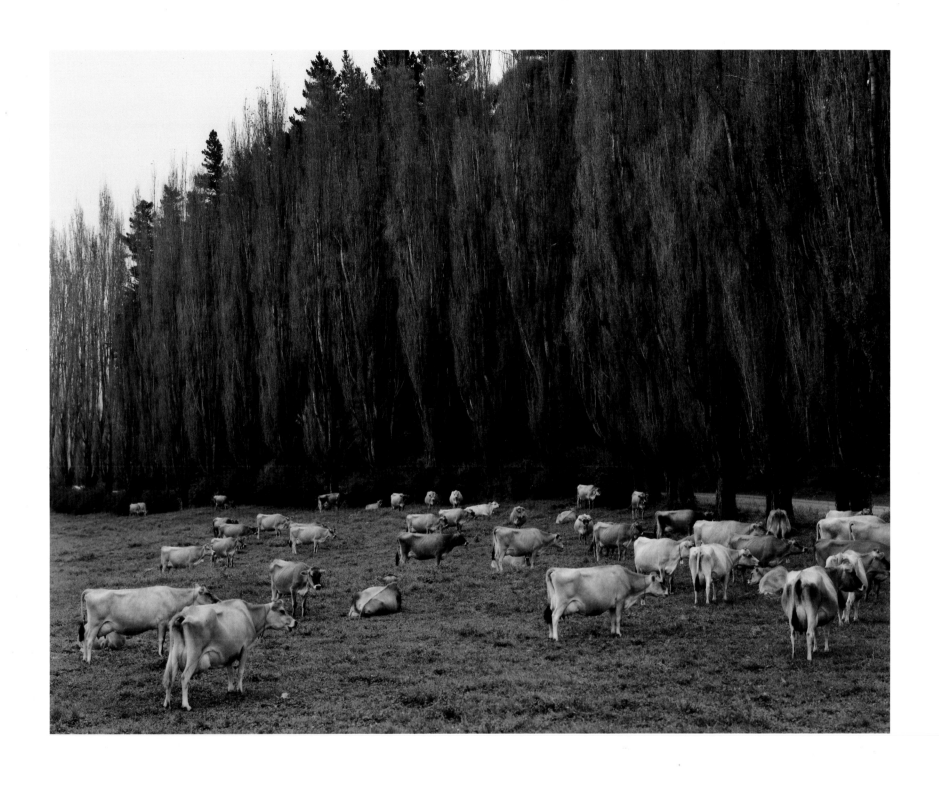

Haine's Summit, Alaska, 1975

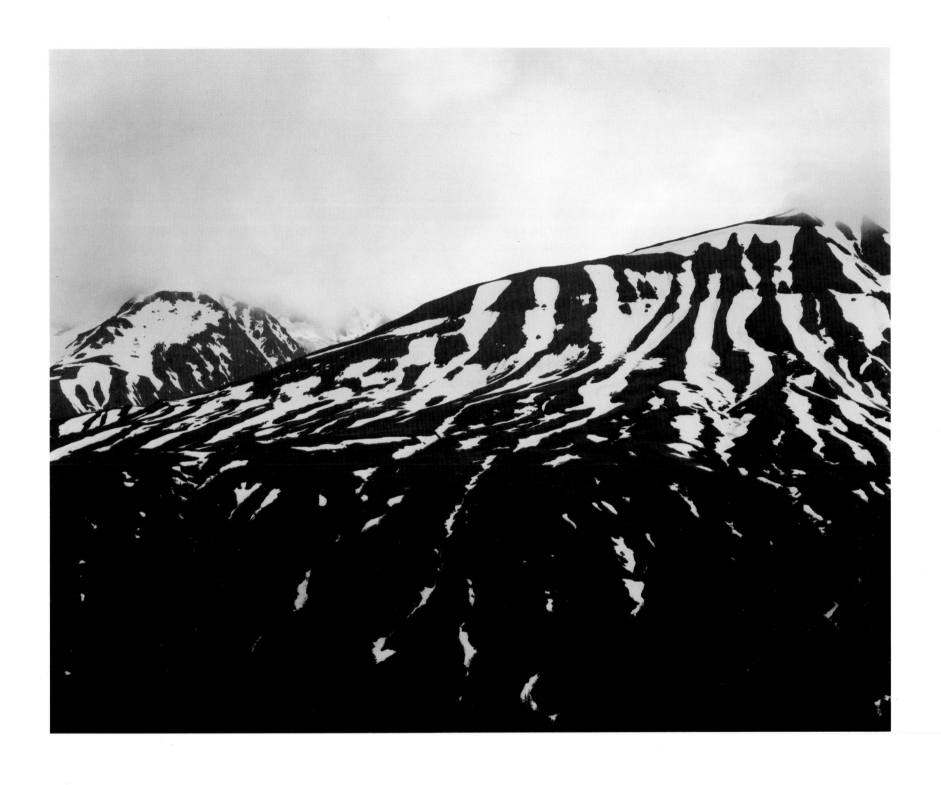

39

Cacti, Southern Utah, 1976

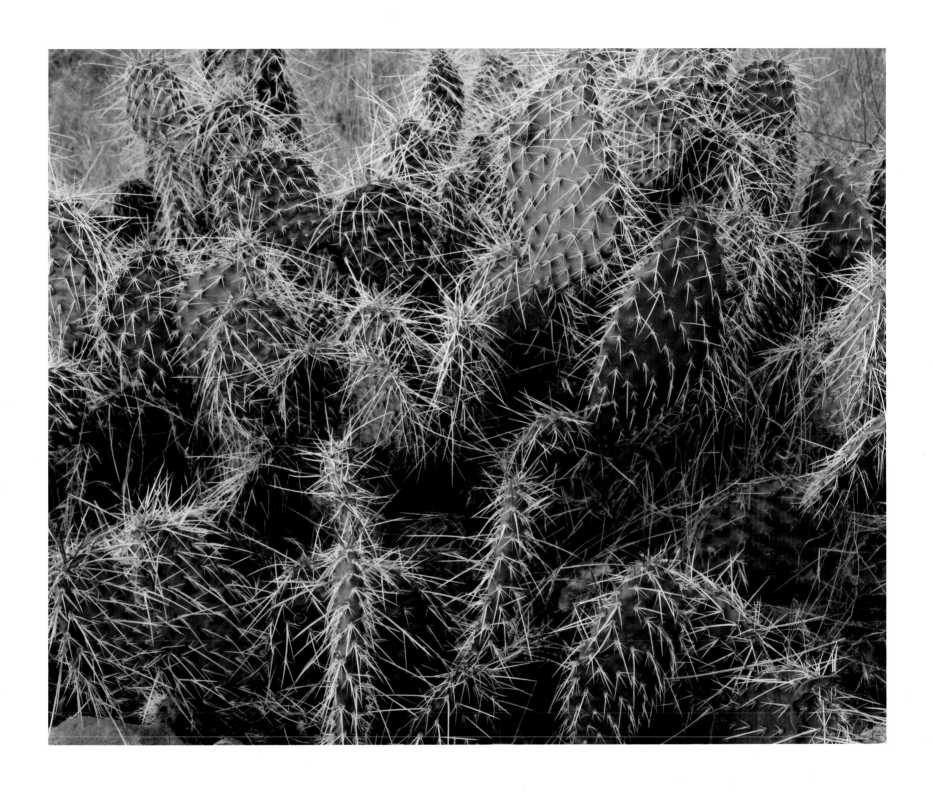

Nude in Window, Arizona, 1979

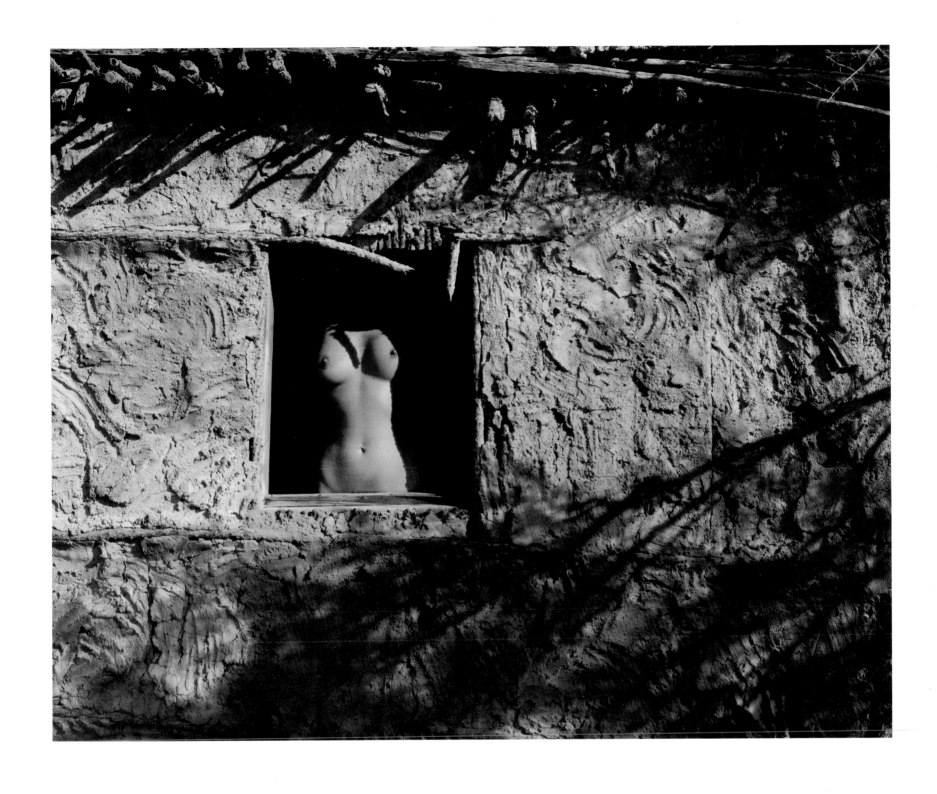

43

Storm, Point Lobos, 1977

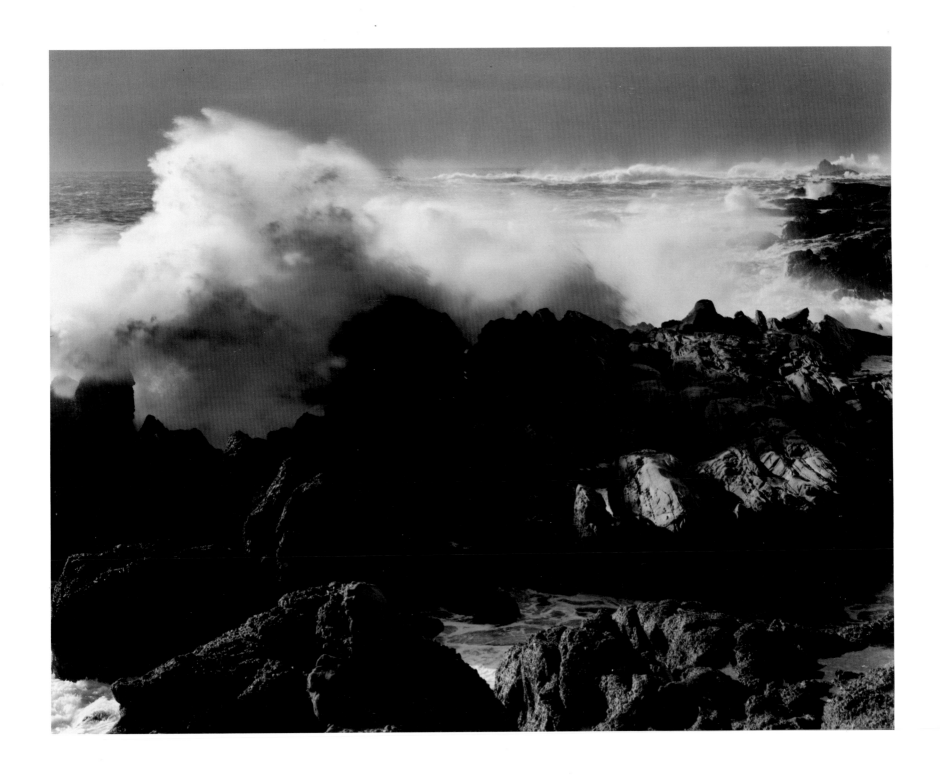

Summer Grass, Mono Lake, 1977

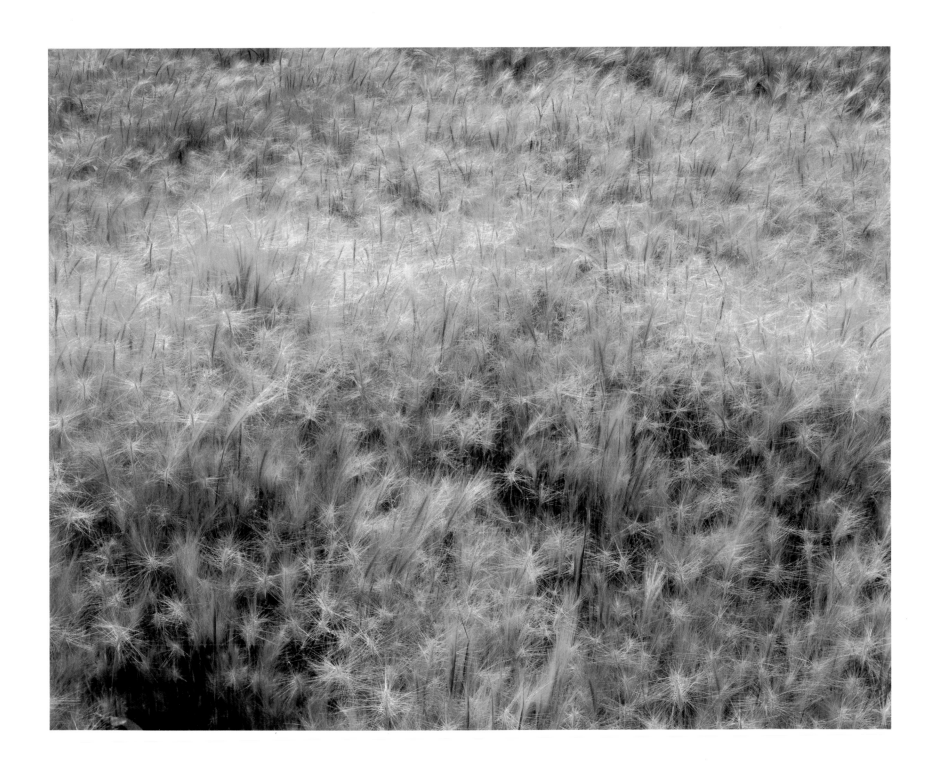

Cow Canyon, Utah, 1976

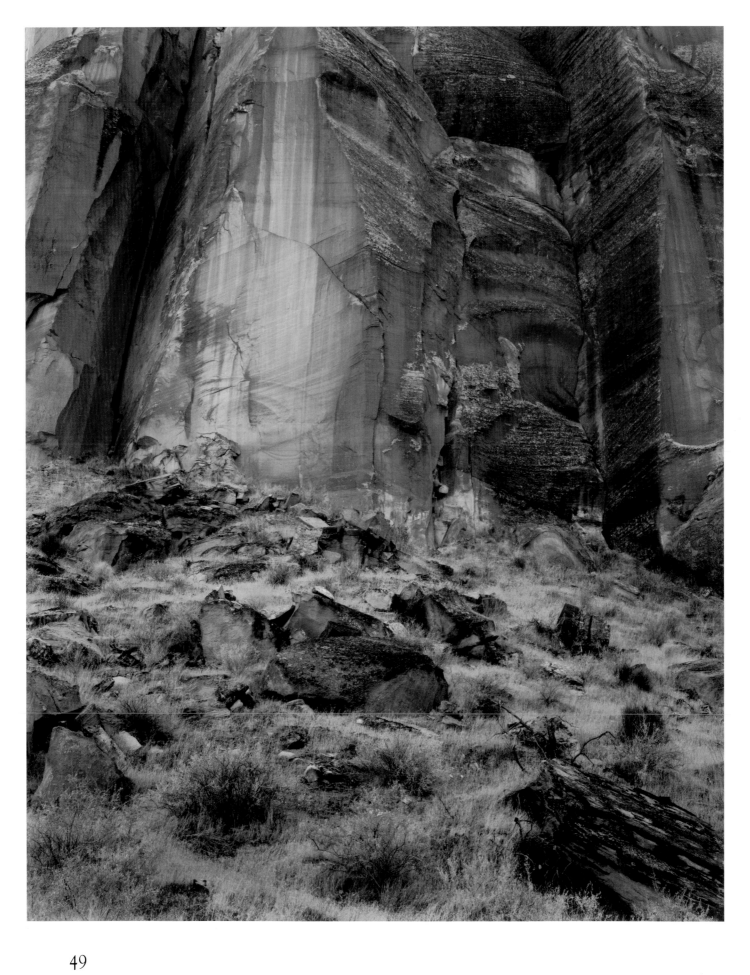

Trapper's Lake, Minnesota, 1979

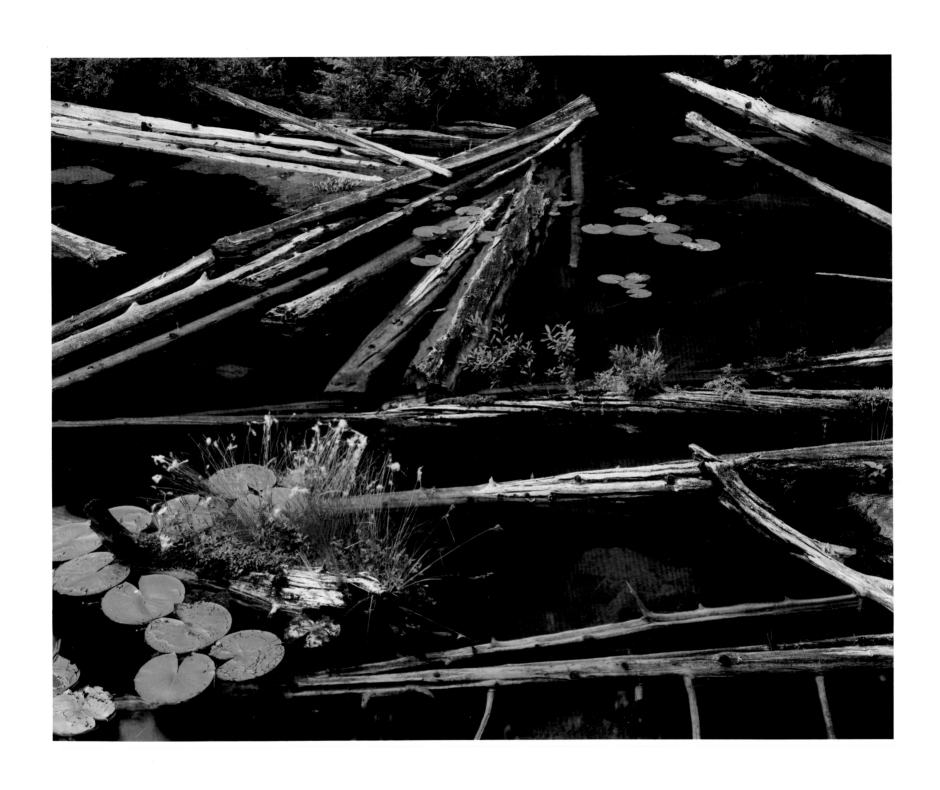

Water Tank, Sedona, Arizona, 1979

Book design by Richard A. Firmage, Salt Lake City.
Composition by Twin Typographers, Salt Lake City.
Printing by Gardner/Fulmer Lithograph, Buena Park.
Binding by Hiller Industries, Salt Lake City.